Wonderful Pussy Willows

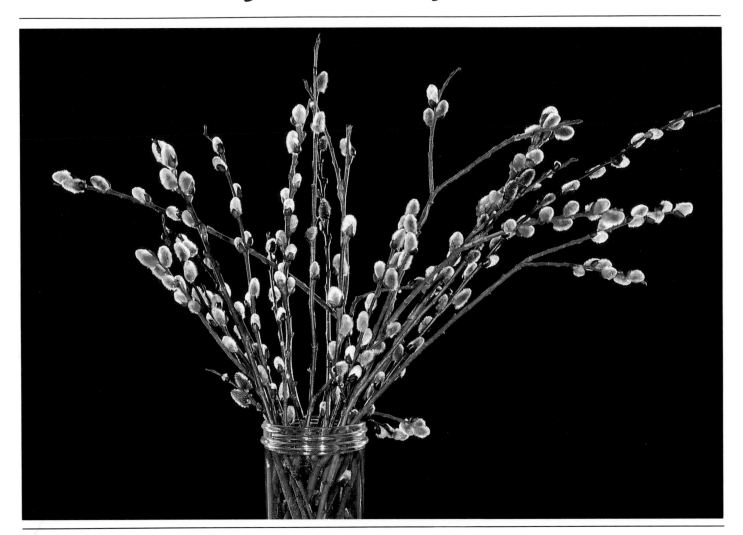

JEROME WEXLER

DUTTON CHILDREN'S BOOKS NEW YORK

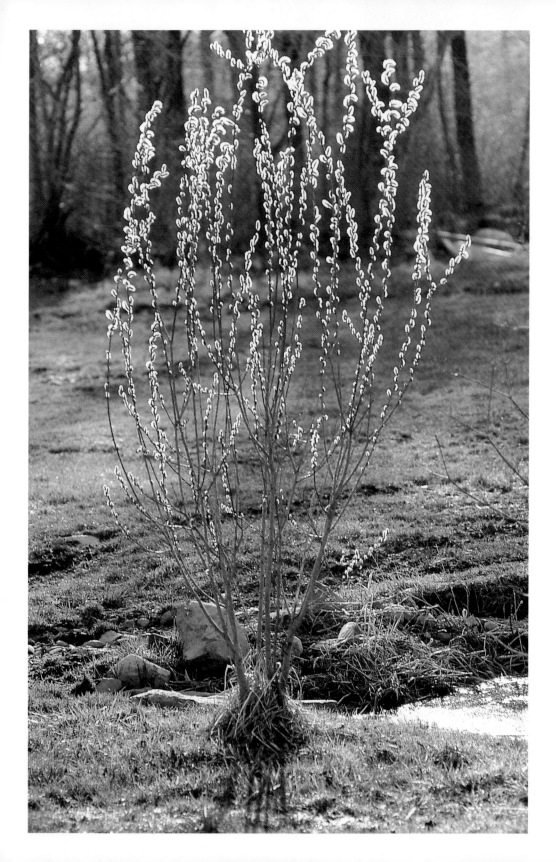

In early spring, when the grass starts to peek through the warming earth,

and it still occasionally snows,

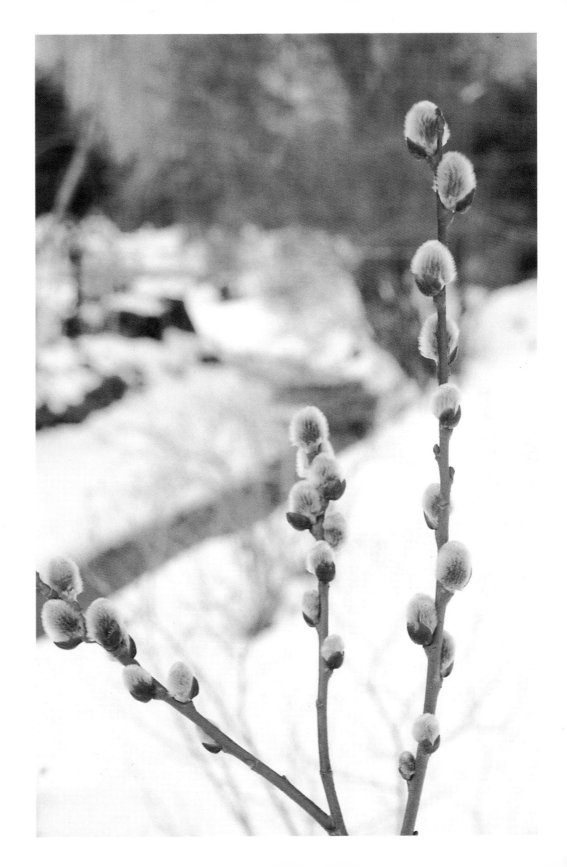

the buds on a plant related
to the weeping willow tree
start to grow. You will find
the plant in damp, slightly
shady areas

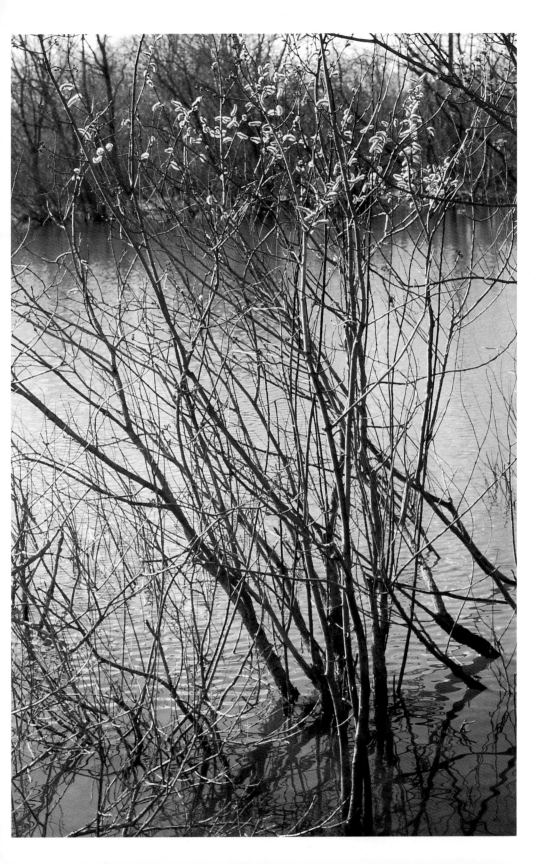

or next to and—when it
floods—even in water.

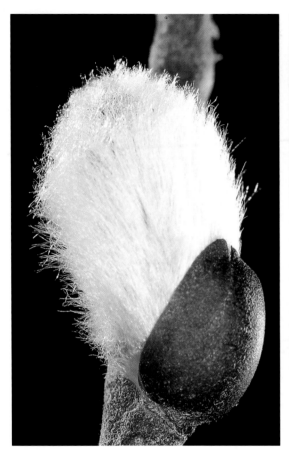 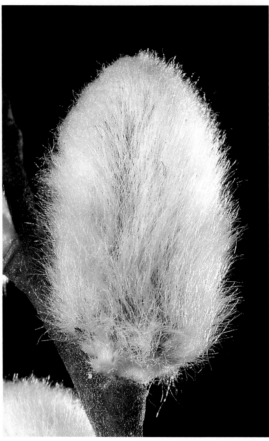 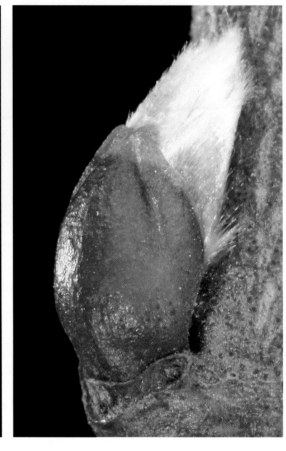

Some of the buds on this plant are soft, fuzzy, and white. If you were to stroke one, it would feel like a cat's silky fur. In fact, the soft white thing is called a catkin, a word that means "small cat."

People must have looked at this plant with its furry catkins and been reminded of pussycats and pussycat tails. Perhaps that is why this relative of the weeping willow is called a pussy willow.

All winter long, a special leaf—a bud scale—helps protect each catkin from the cold. As the days become warmer and the catkins larger, the bud scales are no longer needed and fall off.

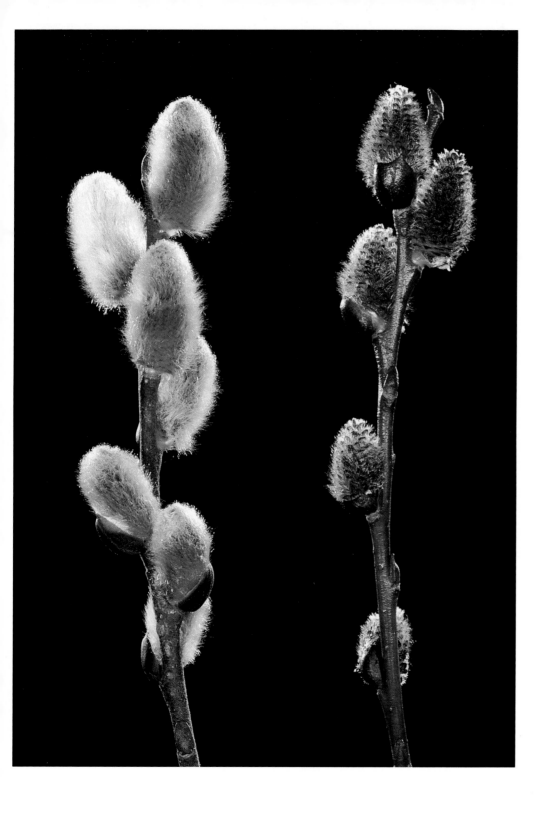

Catkins don't look like leaves. They don't look like flowers, either. What are they? To find out, we must watch and wait.

The warmer the days, the faster the catkins grow. When they are about an inch long, something new appears on them—very tiny flowers. The flowers began to form last fall. They were insulated over the winter and early spring by the catkin hairs. Now it is time for the flowers to grow.

Pussy willows produce two different kinds of flowers.
One kind is called pistillate. Some people call them female flowers.
The catkin that holds them is called a female or pistillate catkin.

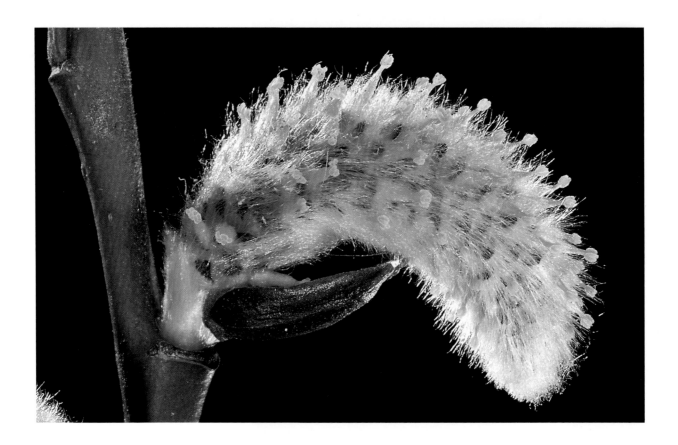

A catkin with pistillate flowers looks like this. Actually, a catkin can be thought of as an arrangement of many flowers in a special pattern.

The other kind of flower is called staminate. Some people call them male flowers. The catkin that holds them is called a male or staminate catkin.

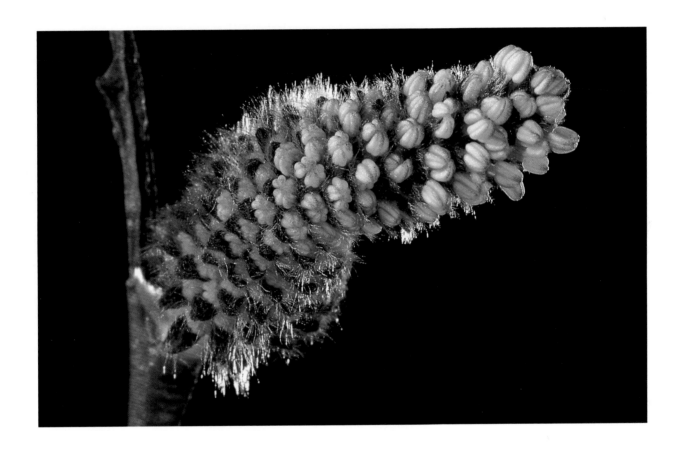

A catkin with staminate flowers looks like this.

All of the flowers on a pussy willow plant are either pistillate or staminate. For this reason, some people refer to a pussy willow plant as either a pistillate or a staminate plant—a female plant or a male plant. You rarely find both kinds of flowers growing on the same plant.

Every catkin contains many, many flowers. Each flower is about the size of this dash— Using a magnifying glass, plus a pair of fine tweezers, it's possible to remove a single flower.

This is a pistillate (female) flower. It has no petals, but it does have three important parts—at the top, in the middle, and on the bottom. At the top of the flower is a little platform called the stigma. It will receive something useful from the male flower. In the middle is a tubelike structure called the style. At the bottom of the style is a roundish area called the ovary.

The ovary contains something special. Inside, hidden from view, are a dozen or more female reproductive cells—egg cells called ovules.

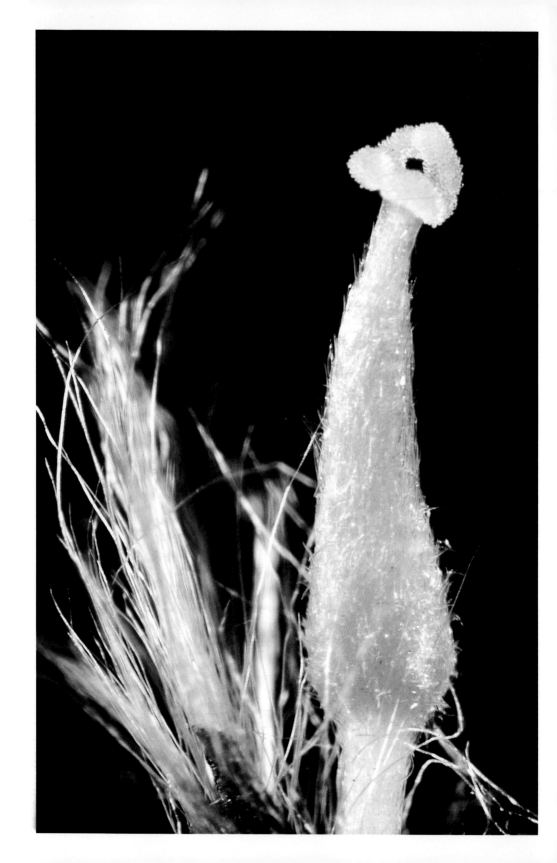

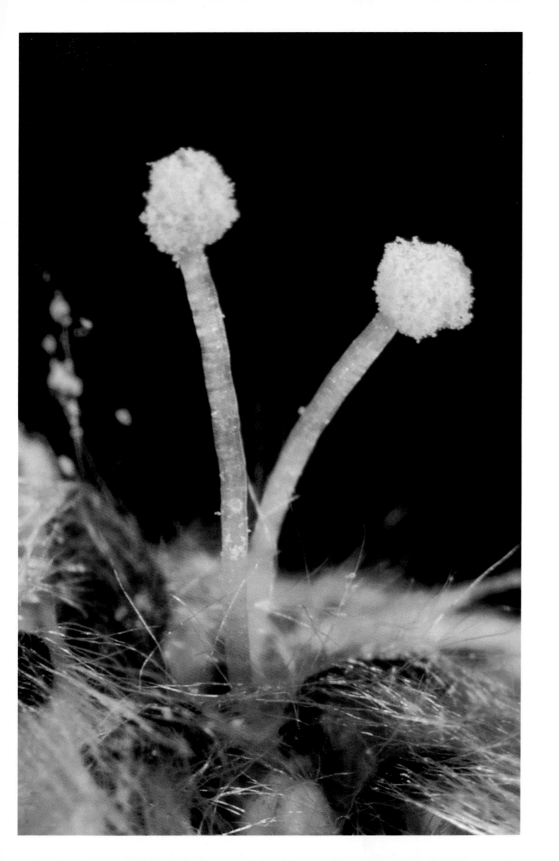

This may look like two flowers, but it is really one staminate (male) flower. It too has no petals. It consists of two round, yellow knobs called anthers, which sit upon two threadlike stalks called filaments. The male reproductive cells develop within the anthers. When the cells are mature, the anthers open, releasing their contents —bright yellow grains of pollen. However, the pollen grains themselves are not the reproductive cells—they contain the reproductive cells.

Pussy willow pollen is very lightweight. The slightest breeze can pick it up and carry it long distances. But there is another, more important way that pussy willow pollen gets transported.

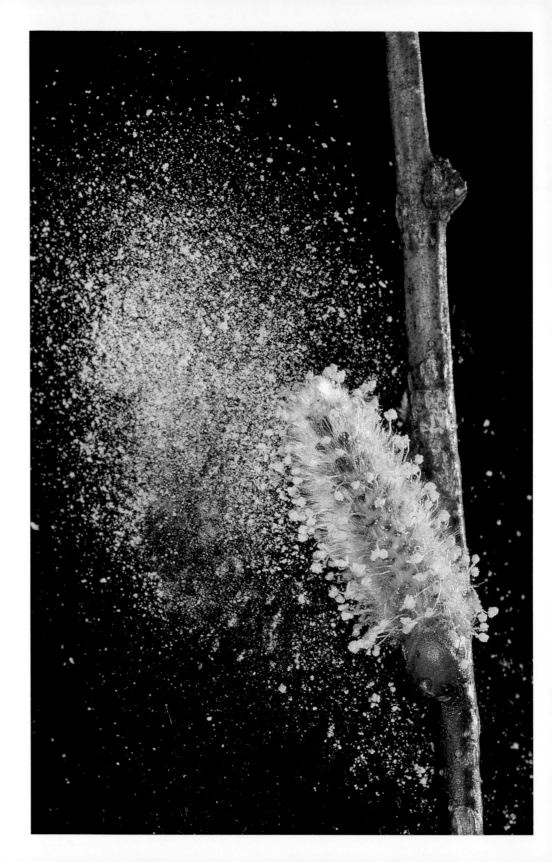

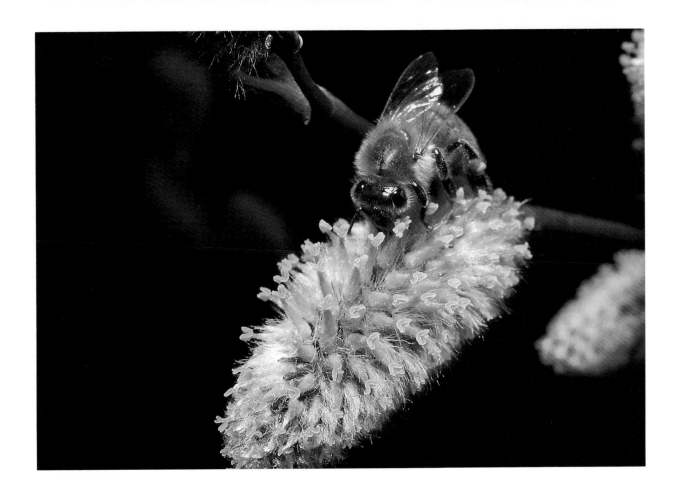

When a hairy insect, like a bee, visits male flowers in search of nectar, some of the pollen grains stick lightly to its hairs. Then, if the bee visits female flowers, some of the pollen grains brush off onto a sticky, tacky substance produced by the stigmas.

A pollen grain that lands on the stigma of a female flower sends a pollen tube down the style to the ovary. The male reproductive cells travel down the style and unite with the ovules in the ovary. This process is called fertilization. Once a male cell and a female cell unite, something wonderful is underway. The fertilized ovules start to change into seeds.

At first, the seeds are microscopic—just little embryo seeds.

As the weeks go by and the embryo seeds develop, the ovaries swell. The catkins themselves become longer and fatter. The stigmas and styles, having served their purpose for fertilization, dry and shrivel.

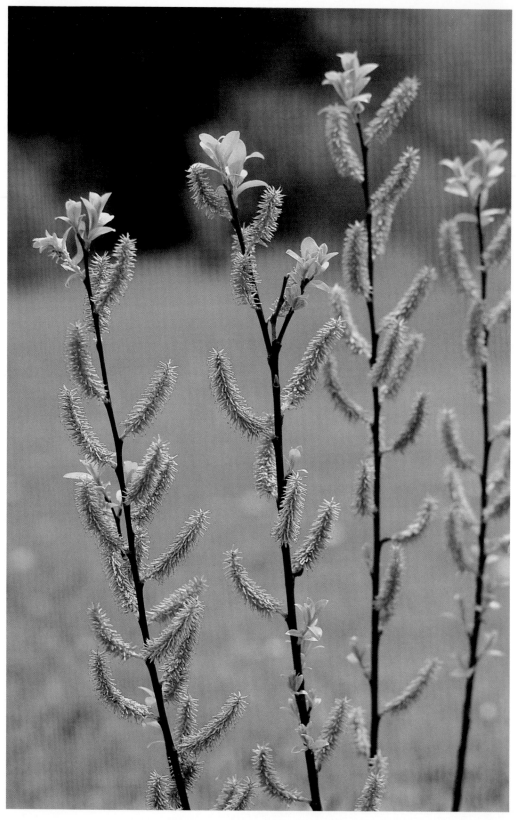

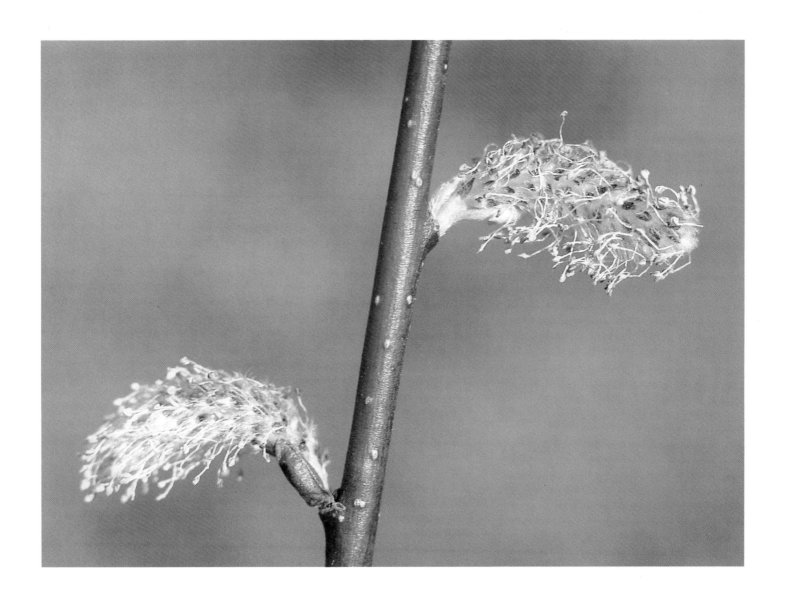

Once the male flowers have shed their pollen, the anthers and filaments turn brown and die. Eventually the whole male catkin will fall off the plant.

About this time, something else happens. The plant's leaves push their way out of their buds and reach full growth in a matter of days. The bright green leaves are long and narrow. Each has a little skirt at its base.

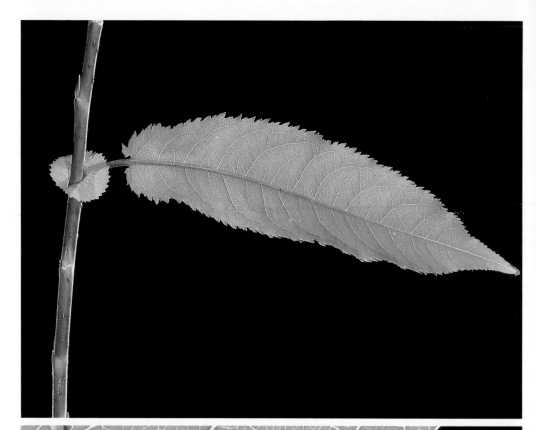

The green color comes from a pigment called chlorophyll. In the presence of sunlight, chlorophyll helps turn water and carbon dioxide into sugars and starches—food for the plant. In the process, oxygen is released into the air, which animals, including humans, breathe.

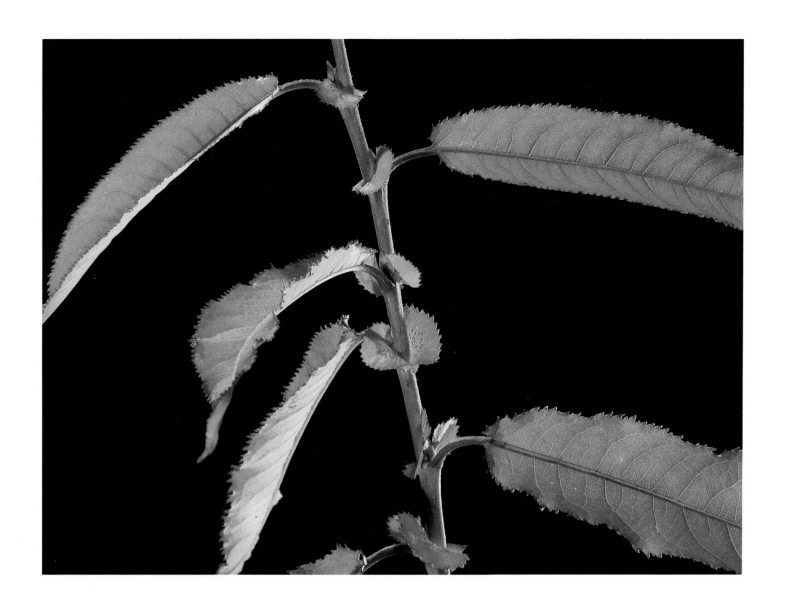

The pussy willow leaves grow from the stem in a pattern that enables each leaf to receive a good share of sunlight.

As the weeks pass, the female catkins continue to grow and change. The hairs drop off. Now you can clearly see the ovaries that have been enlarging to make room for the seeds ripening within.

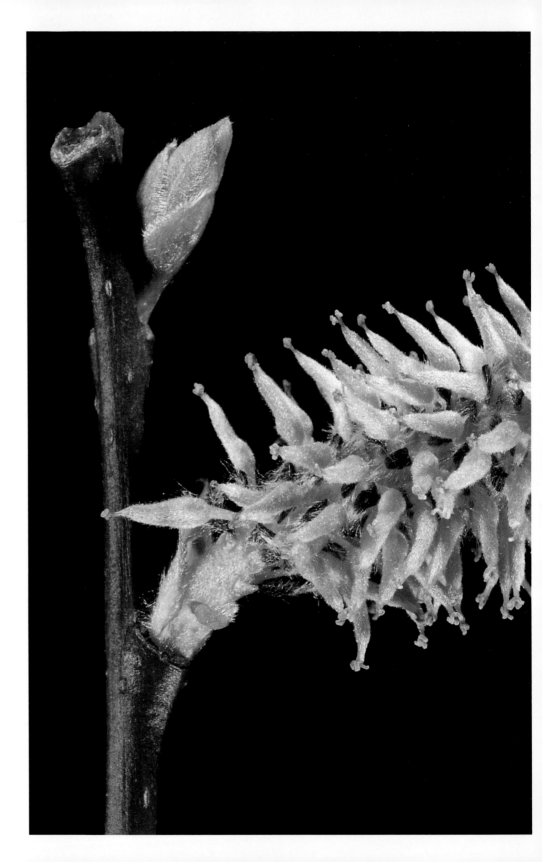

Most people use the word *fruit* to refer to a sweet, juicy or crisp food. However, a botanist—a plant scientist—uses the word *fruit* to describe an ovary that contains ripe, or mature, seeds.

Fruits—that is, ovaries with ripe seeds inside—vary greatly in size, shape, and form. They also have many different names. The fruit of a pea plant is called a pod. The fruit of a maple tree is called a key. The fruit of a tomato plant is called—no, not a tomato but a berry. And the fruit of the pussy willow is called a capsule. The picture at left shows many ripening capsules.

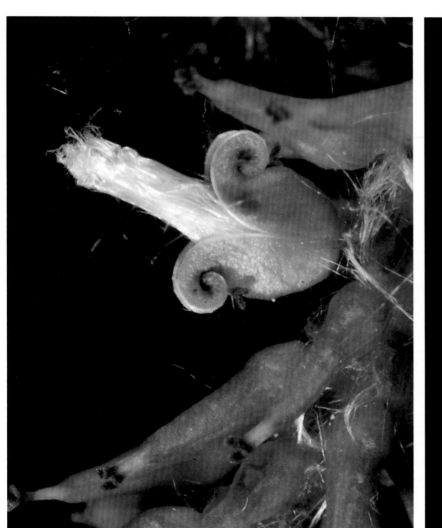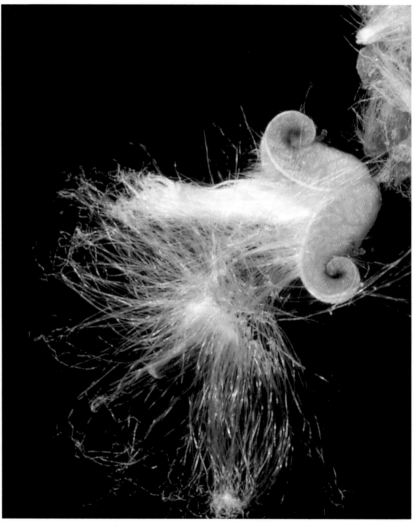

More time has passed.
It's now early June. The ripe
capsules begin to open.

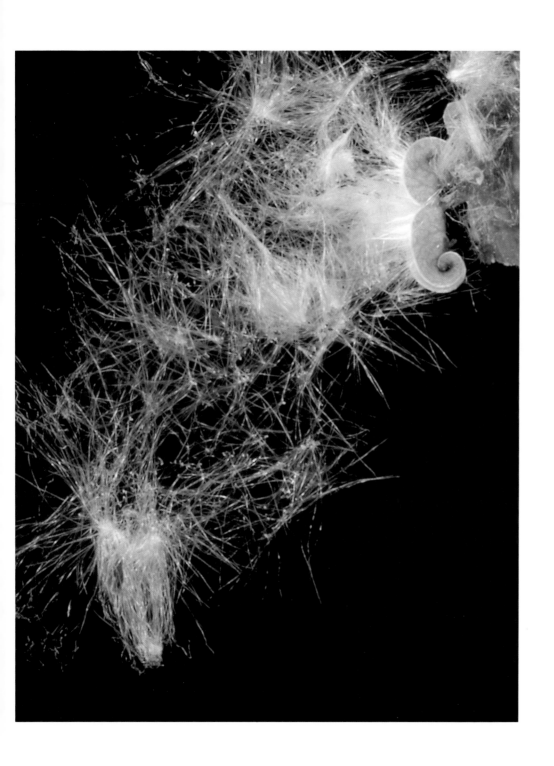

If it's not raining, the warm, dry June air tickles the contents into fluff. With every breeze, bits of silkiness go floating off . . .

eventually leaving behind the
empty capsule.

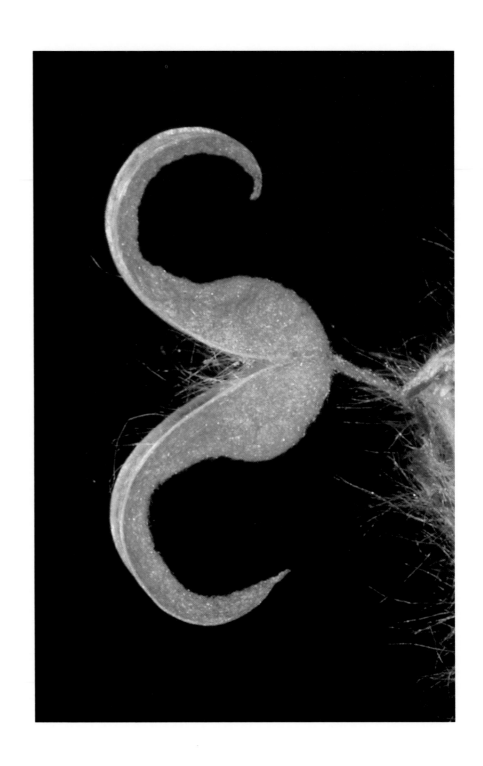

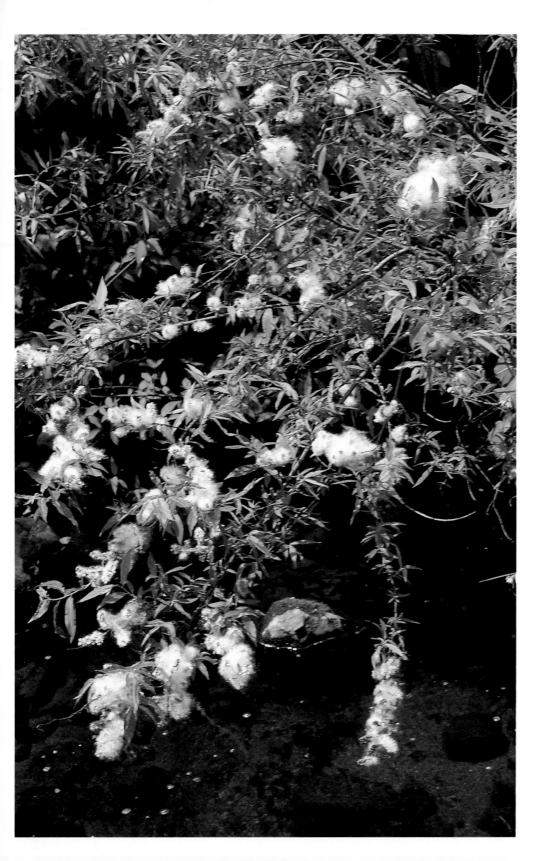

If it's raining, the fluffy material becomes wet and matted. No matter how strong the breeze, the seeds are never distributed.

Seeds! Where are the seeds? Look closely.

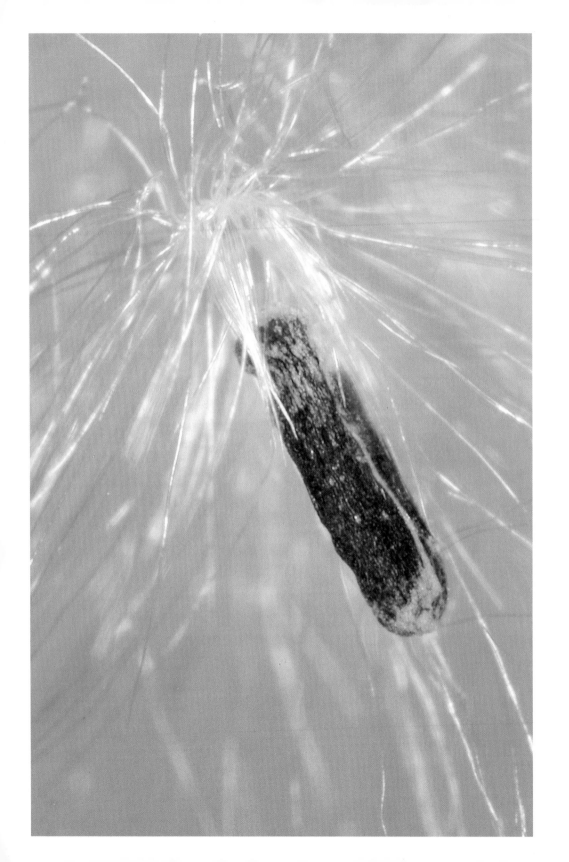

Attached to each bit of fluff is a very, *very* small seed. How small?

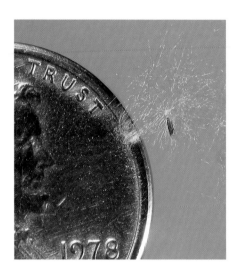

This small!

Small as it is, the seed contains a tiny plant—an embryo—ready to sprout. The seed also contains a supply of food and water that can nourish the embryo—but only for a few days. So, after leaving its capsule, a pussy willow seed must quickly land in warm, damp soil that gets some sunlight. Otherwise the tiny plant inside will die.

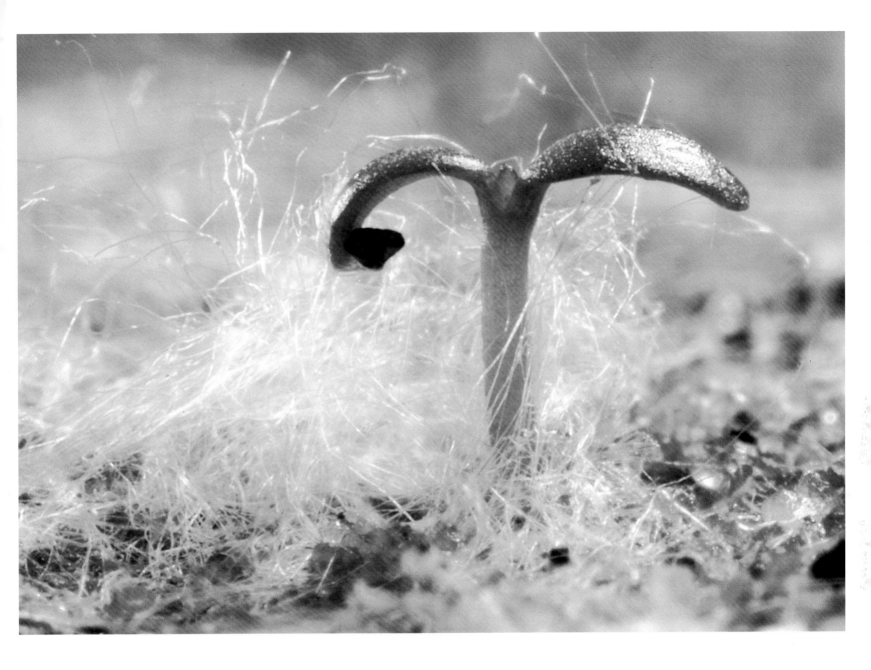

If a seed does land in a good spot, the embryo sprouts within
twelve to twenty-four hours. Growth is rapid. The first leaves push
through the earth within a few days.

This photo was taken on the seventh of June.

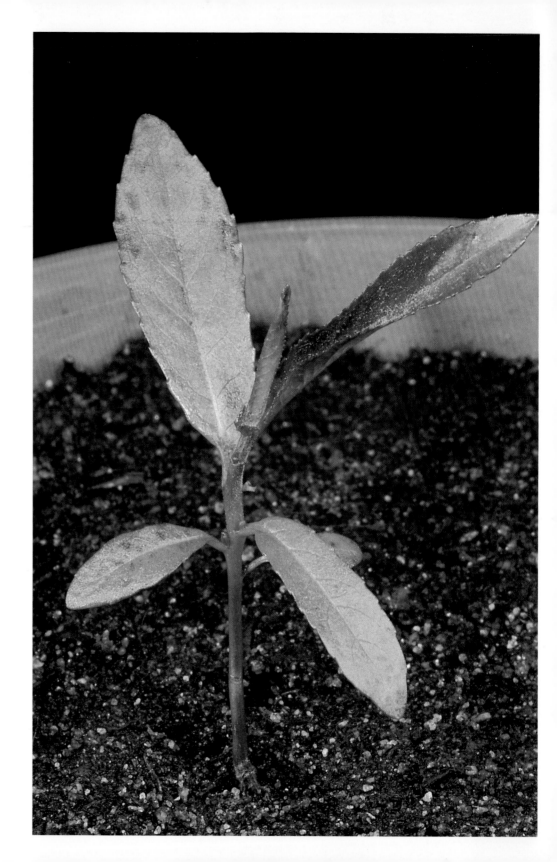

Six weeks later, by the eighteenth of July, several large leaves have appeared.

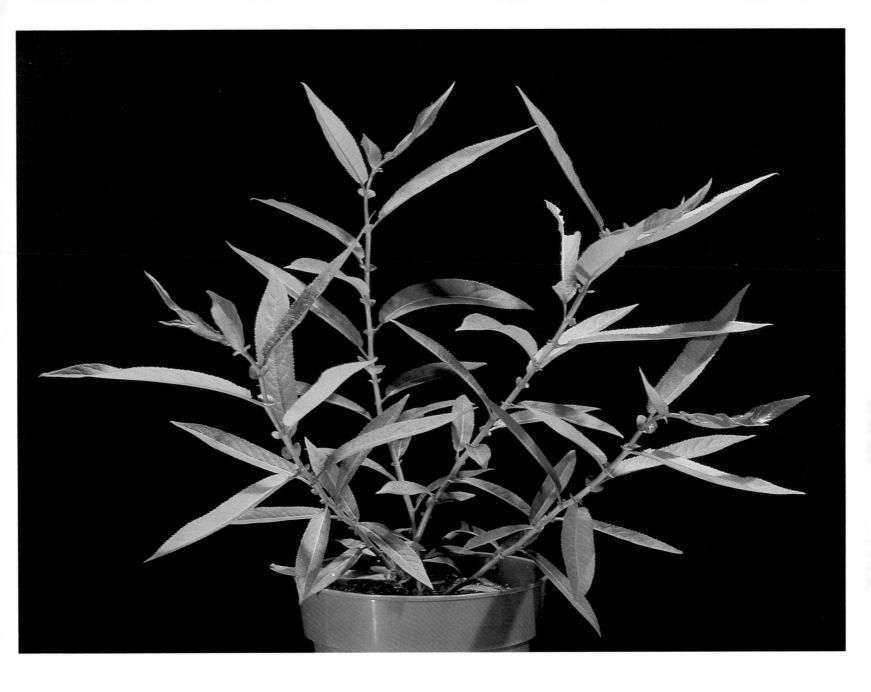

Now the plant is two and a half months old.

Finally, it's the end of the summer—the end of the plant's first growing season. This pussy willow is three and a half months old and over thirty inches tall!

It's approximately a thousand times larger than the seed from which it grew. Suppose you grew that fast. How tall would you have been when you were three and a half months old?

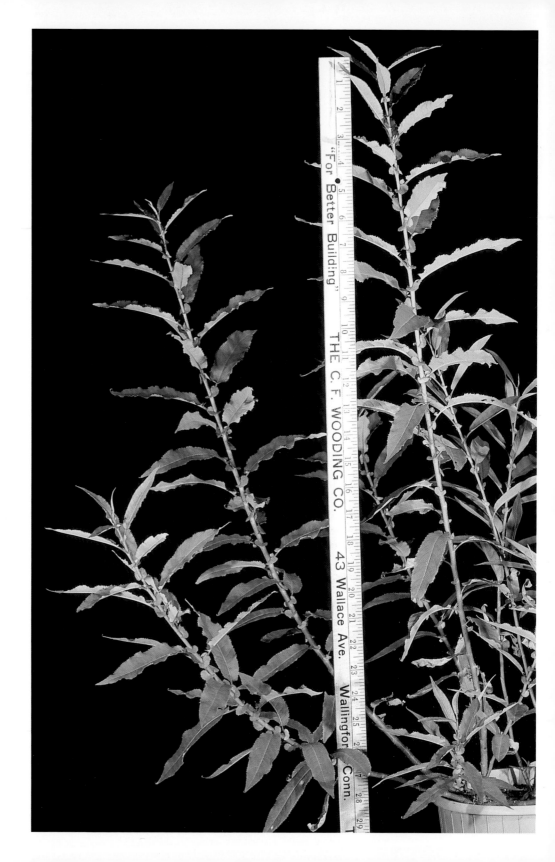

If you are reading this book any time between January and early March, and you know where some pussy willows are growing, ask your parents if they will help you collect a few branches, twelve to fifteen inches long. (Of course make sure that the owner of the plant doesn't mind.)

When you get home, place the branches in a container of water in a warm spot in the house. Be sure to change the water every three or four days. In a week or so, the catkins will start to emerge from their winter buds.

After the catkins are about an inch long and are soft and furry, you may remove a few of the branches and place them in a separate dry container. In a few days, the branches will become dry, and the catkins will stop growing. But they will stay just as they are, soft and furry, for months and even years.

The catkins on the branches left in water will continue to get larger. But in a few weeks something unexpected will happen. Some of the branches will start growing roots!

Later, in springtime, when the soil is warm and soft, find a spot which you believe will be damp most of the year. Take a branch and trim the roots so that they are two to three inches long. Dig a hole about three inches deep and large enough to accept the roots. Then plant the rooted branch.

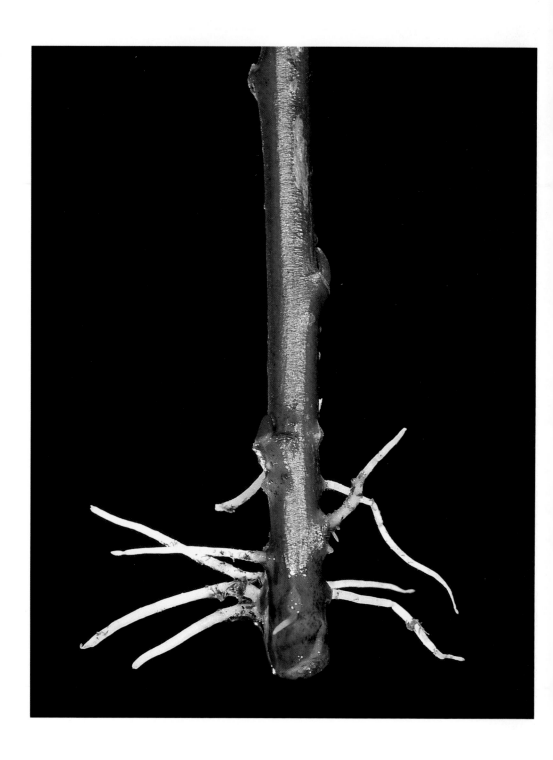

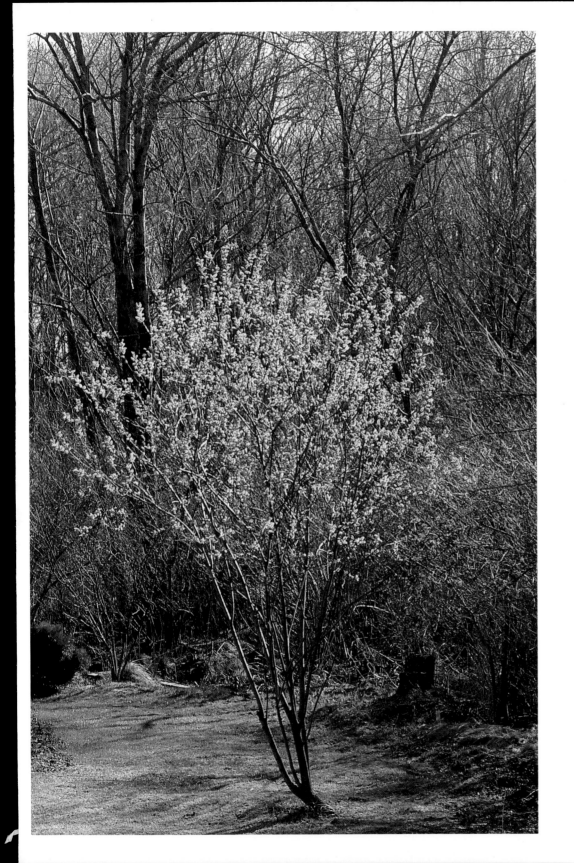

Won't you feel good, five or ten years from now, when you look at your tall pussy willow and know that you helped transform a few short branches into a lovely plant like this? And perhaps someday your very own children will cut branches from that pussy willow and begin their own plant.

Pussy willows belong to a large family of plants. More than eighty different species of willows grow in North America. Some willows are shrubs, and some are trees. Many flower at the same time and tend to cross-pollinate, producing hundreds of hybrids, in addition to the eighty-plus species. Whether a pussy willow is a hybrid or not, its catkins are interesting and beautiful. Enjoy them!

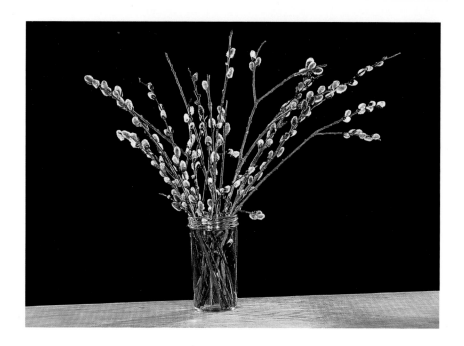

Copyright © 1992 by Jerome Wexler

All rights reserved.

Published in the United States by Dutton Children's Books, a division of Penguin Books USA Inc.
375 Hudson Street, New York, New York 10014

Designer: Riki Levinson

Printed in Hong Kong
First Edition 10 9 8 7 6 5 4 3 2

Library of Congress Cataloging-in-Publication Data

Wexler, Jerome.
 Wonderful pussy willows / by Jerome Wexler.—1st ed.
 p. cm.
 Summary: Describes the appearance, growth, and pollination of the soft white plant that is a relative of the weeping willow.
 ISBN 0-525-44867-5
 1. Pussy willow—Juvenile literature. [1. Pussy willow.]
I. Title.
QK495.S16W49 1992
583'.981—dc20 91-32262 CIP AC